SWEET Cupcakes

Swear Word Coloring Book

Shit

Inspiration and Stress Relief

Variety ♡ Mandala ♡ Designs

Volume.1

COLOR TEST PAGE

COLOR TEST PAGE

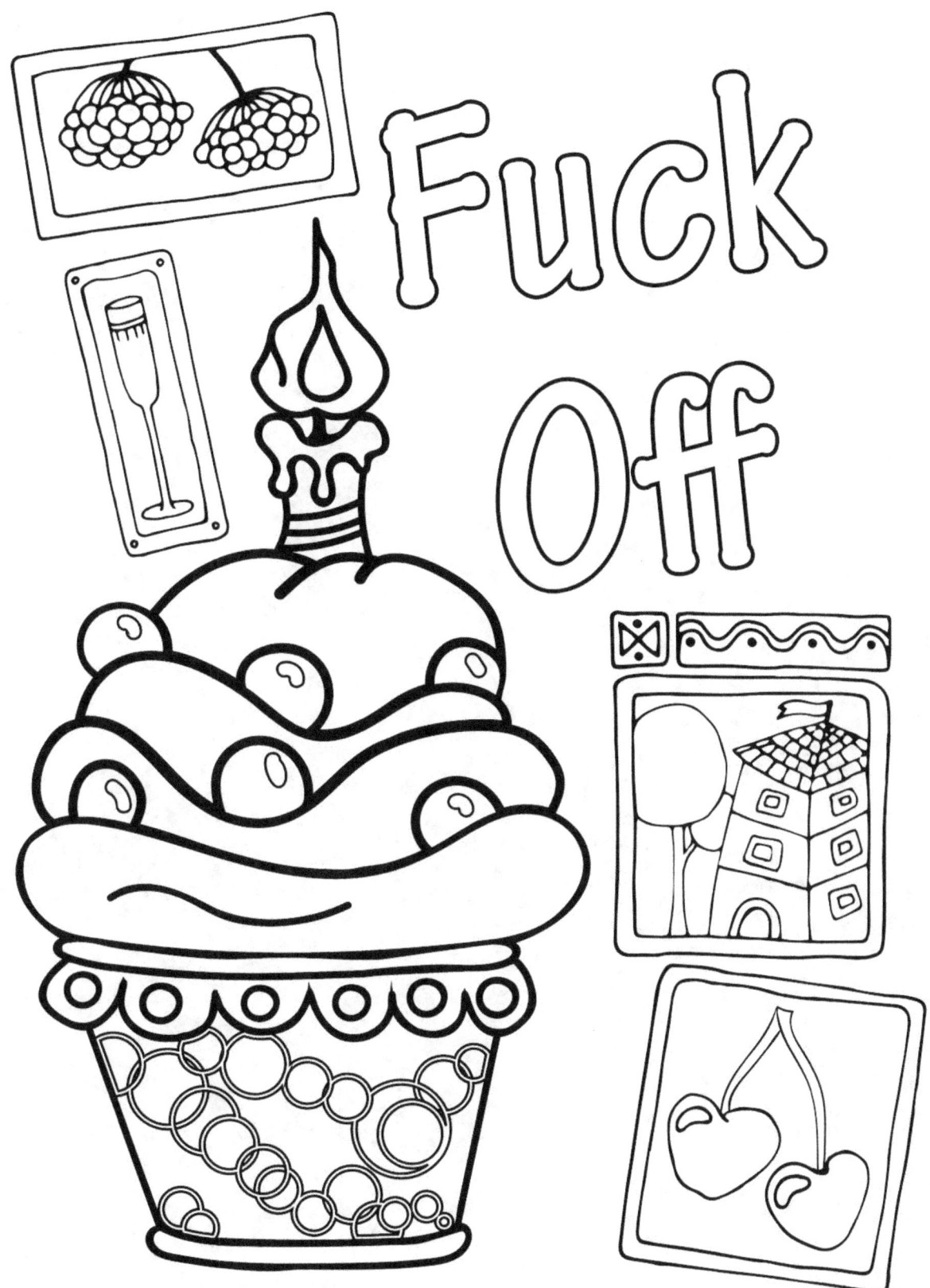

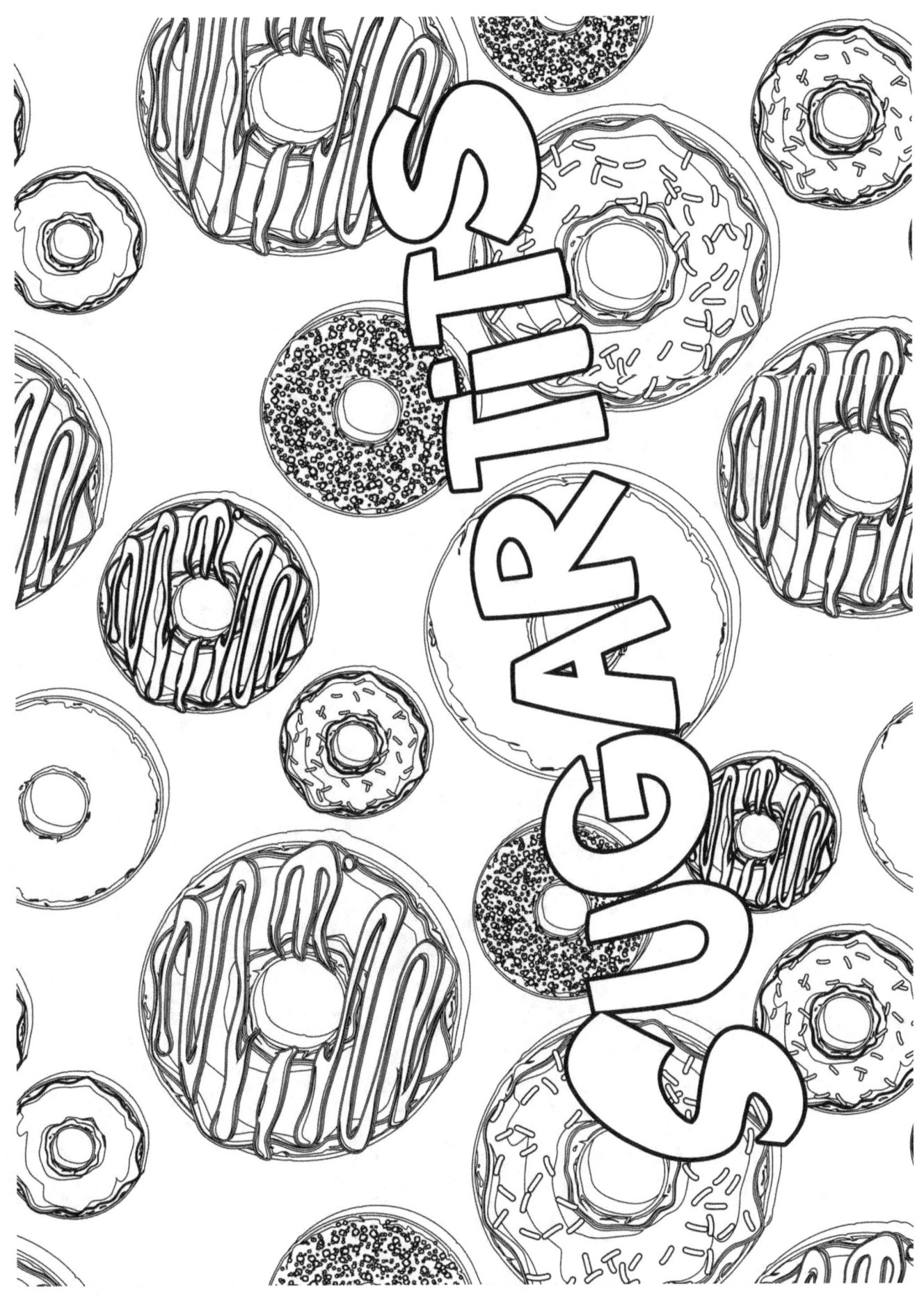

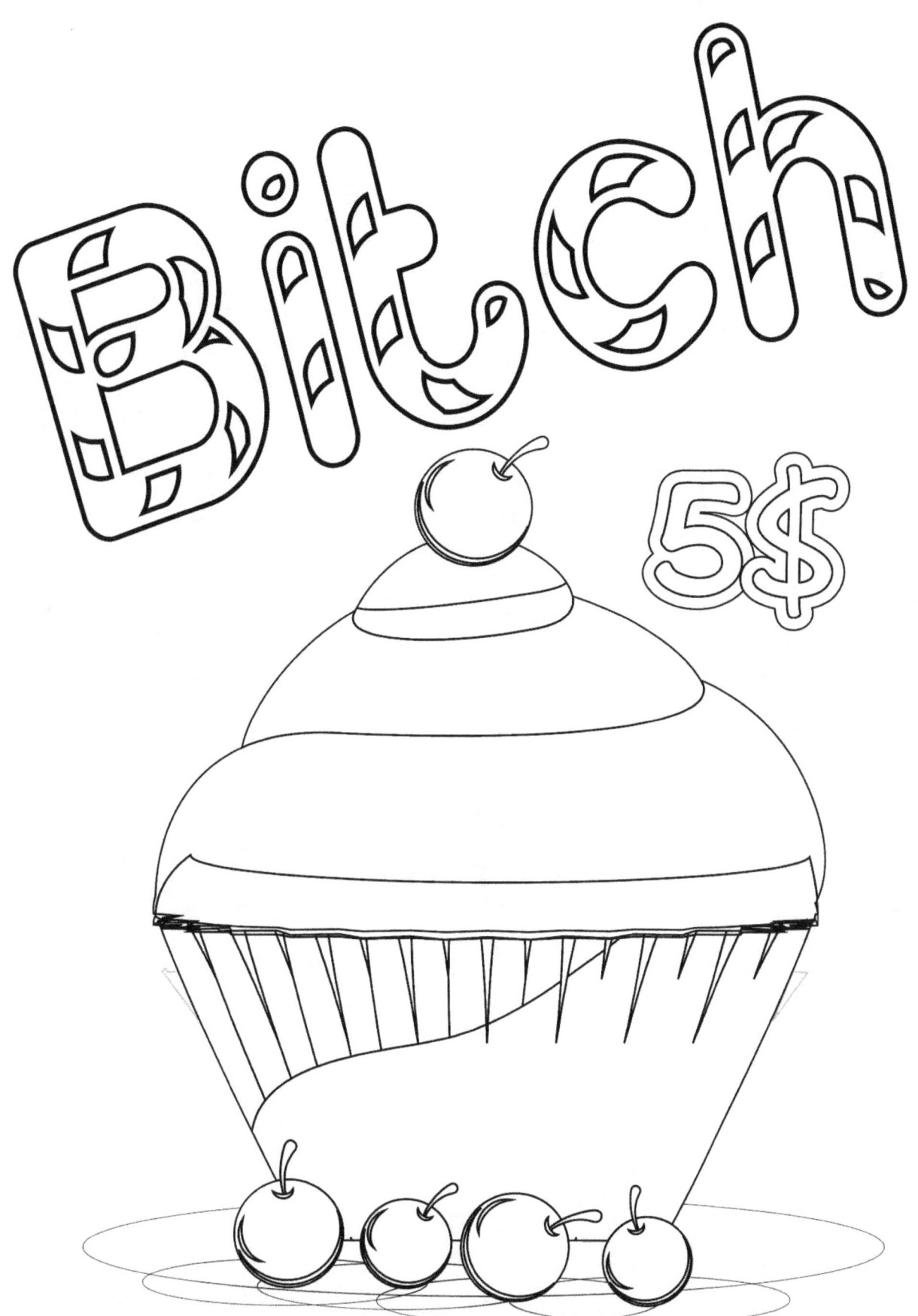

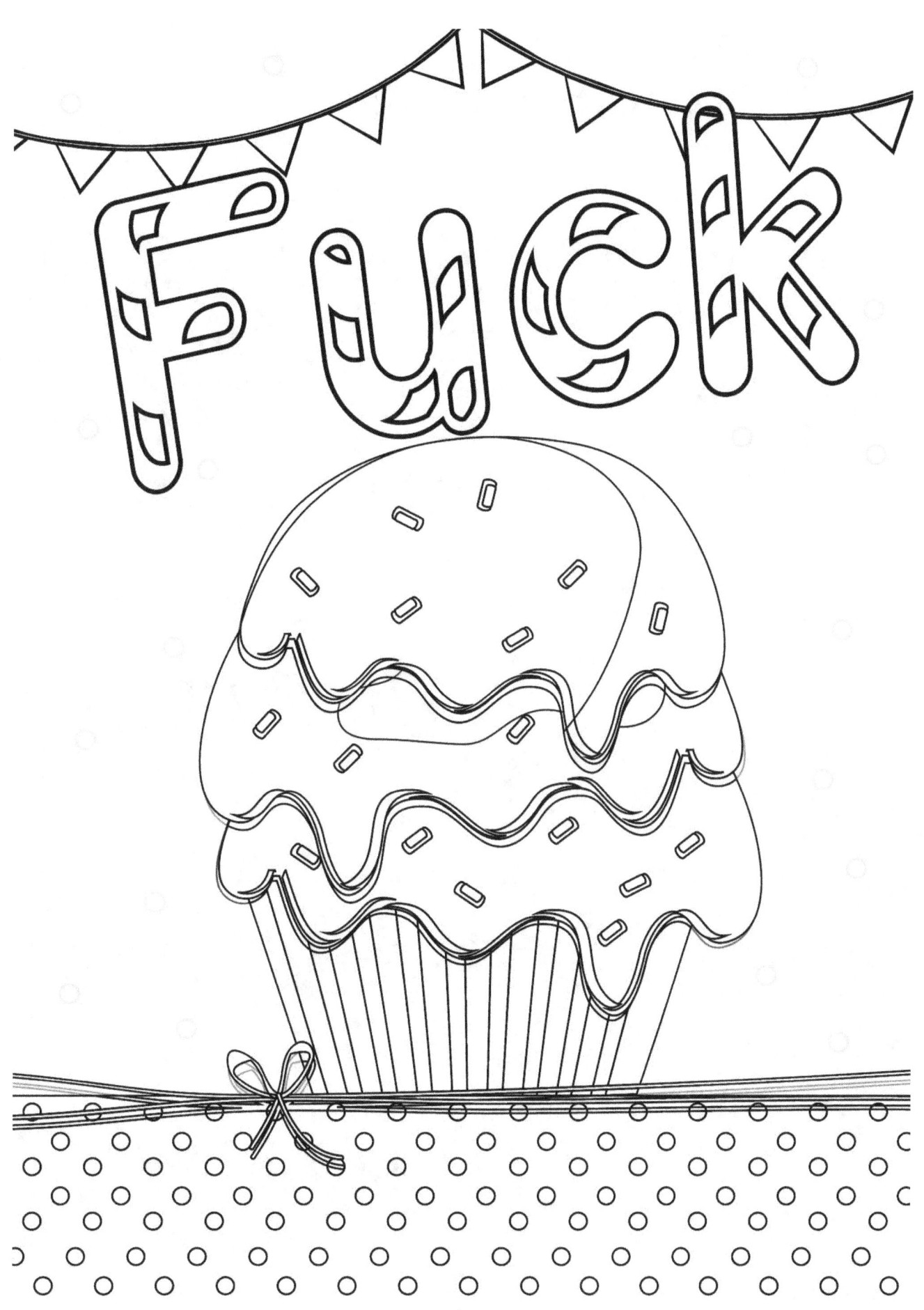

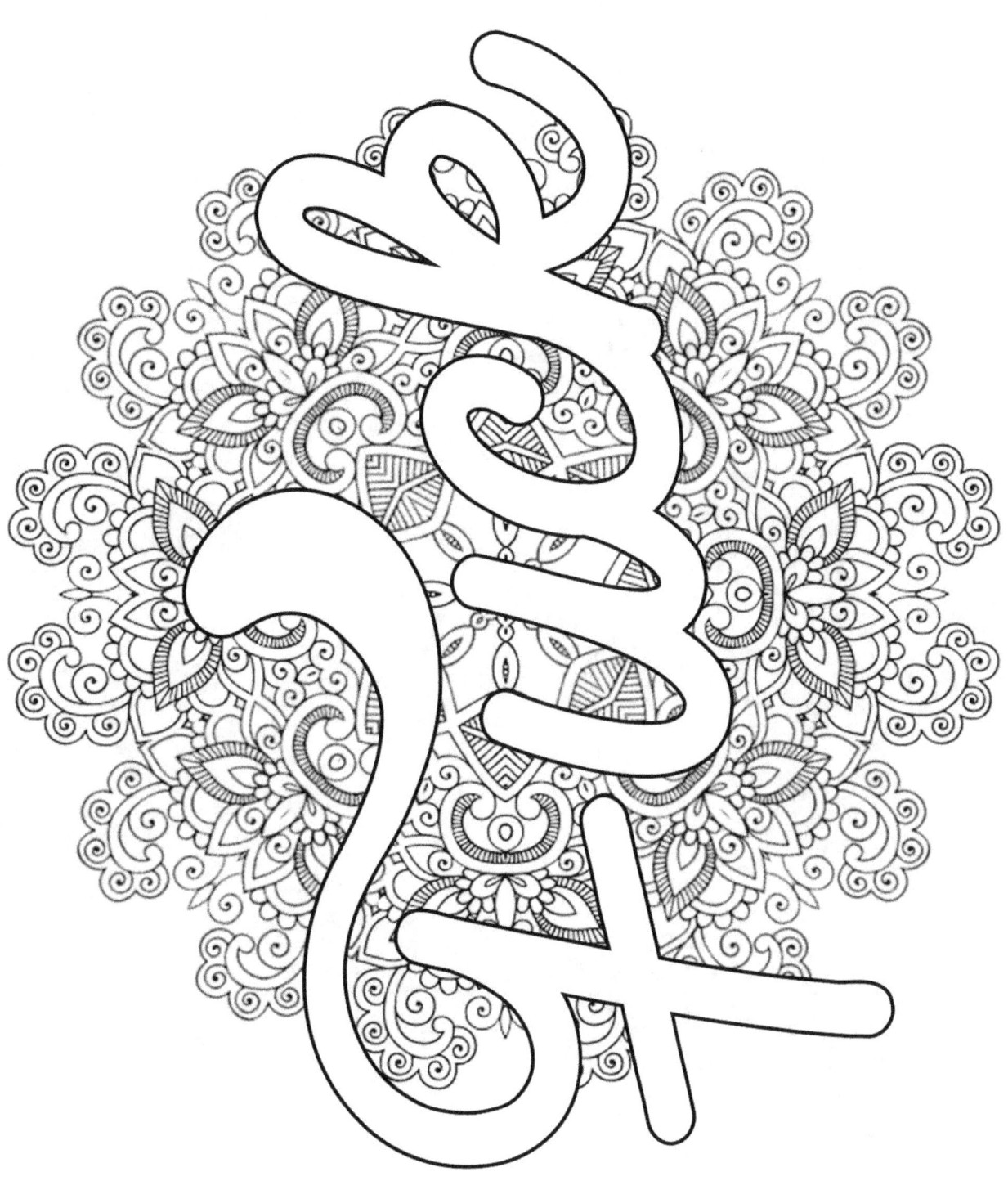

Cunt

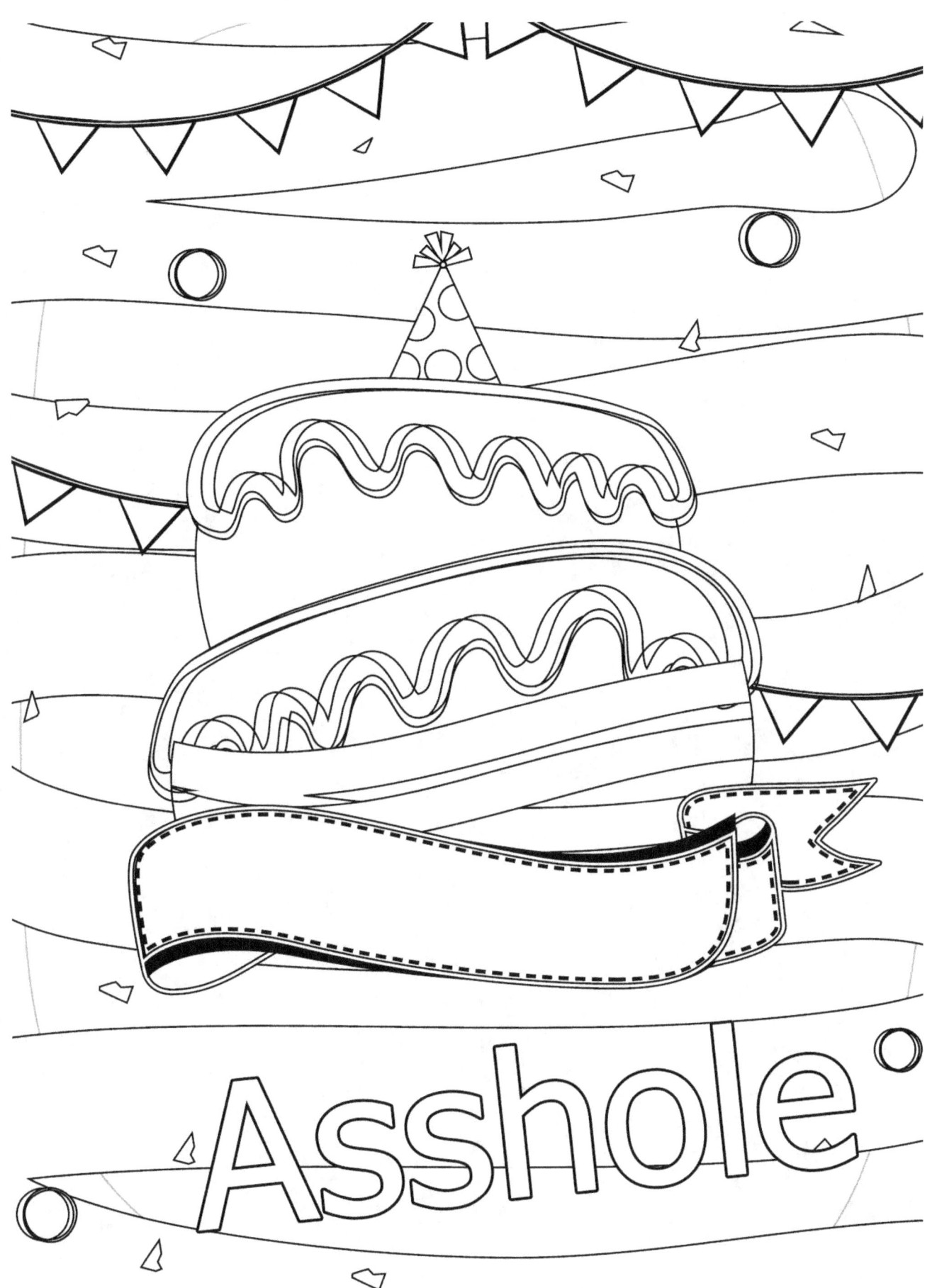

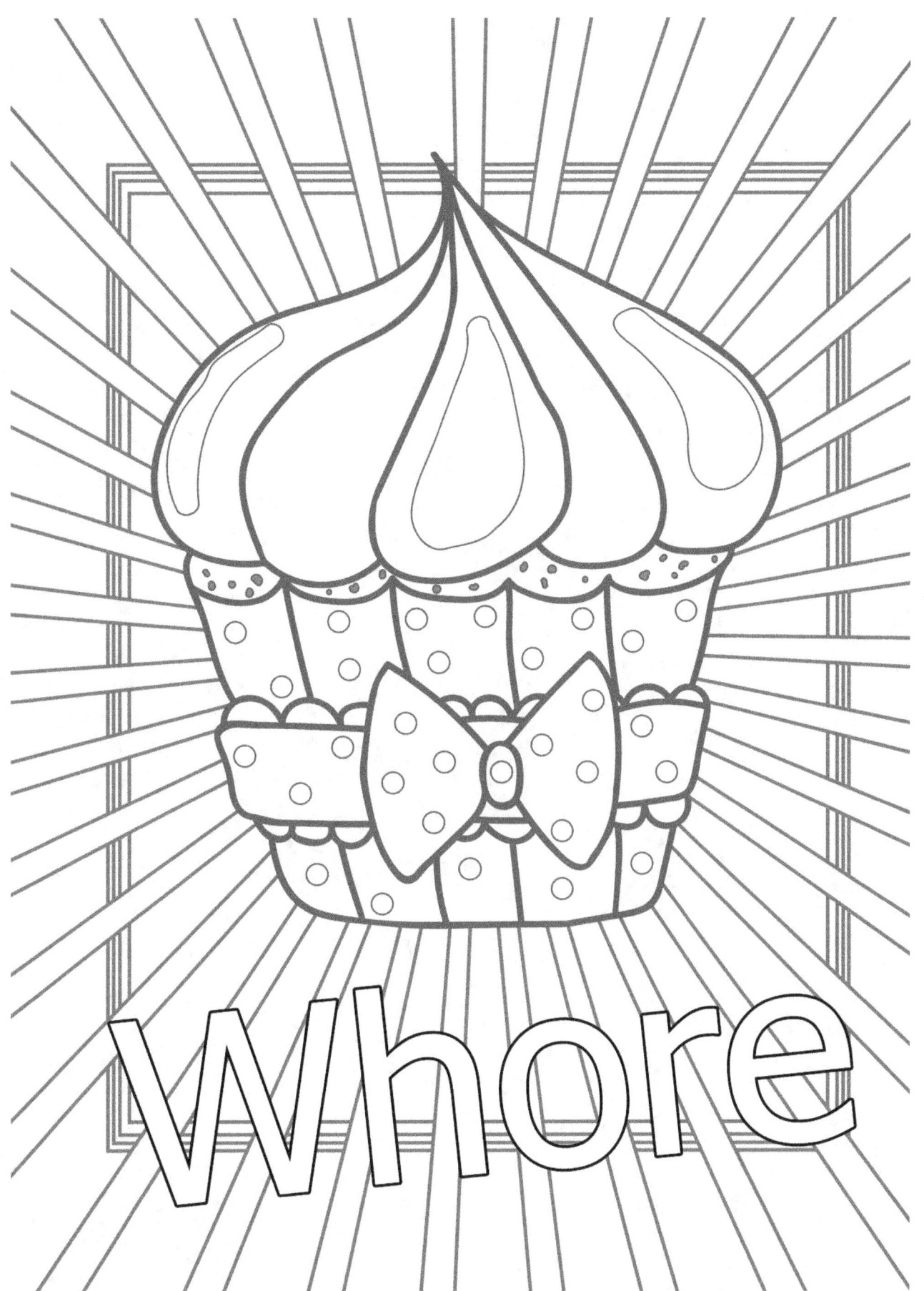

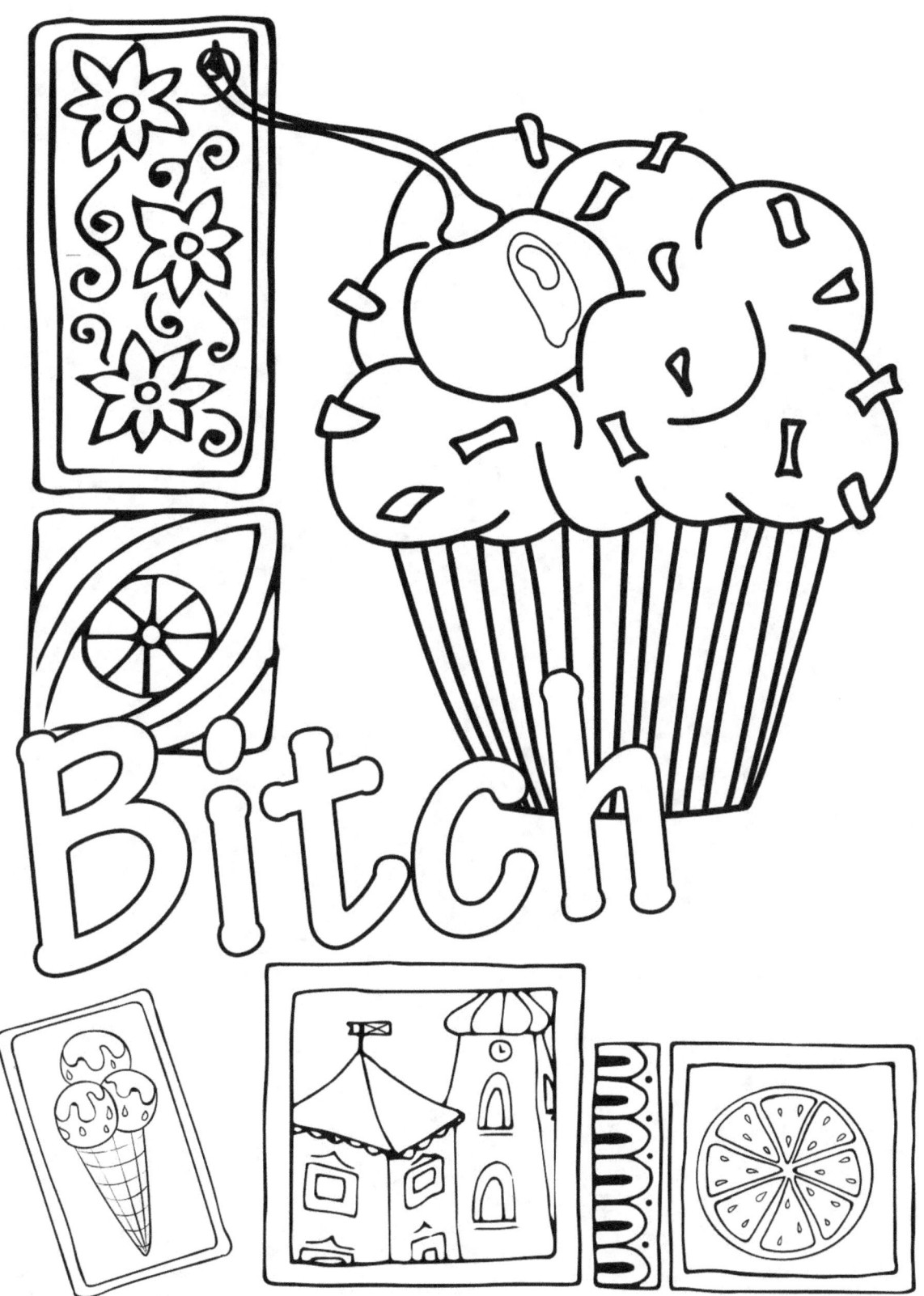

Did I fuck as like!

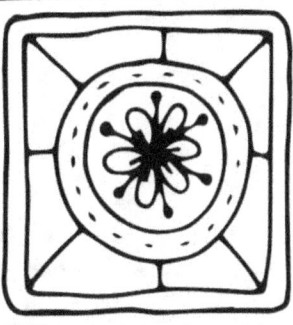
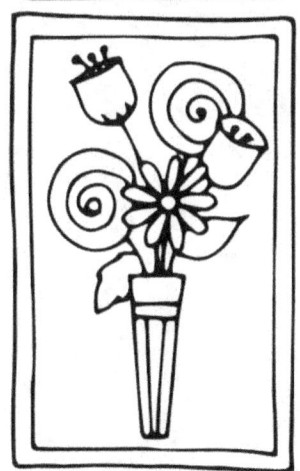
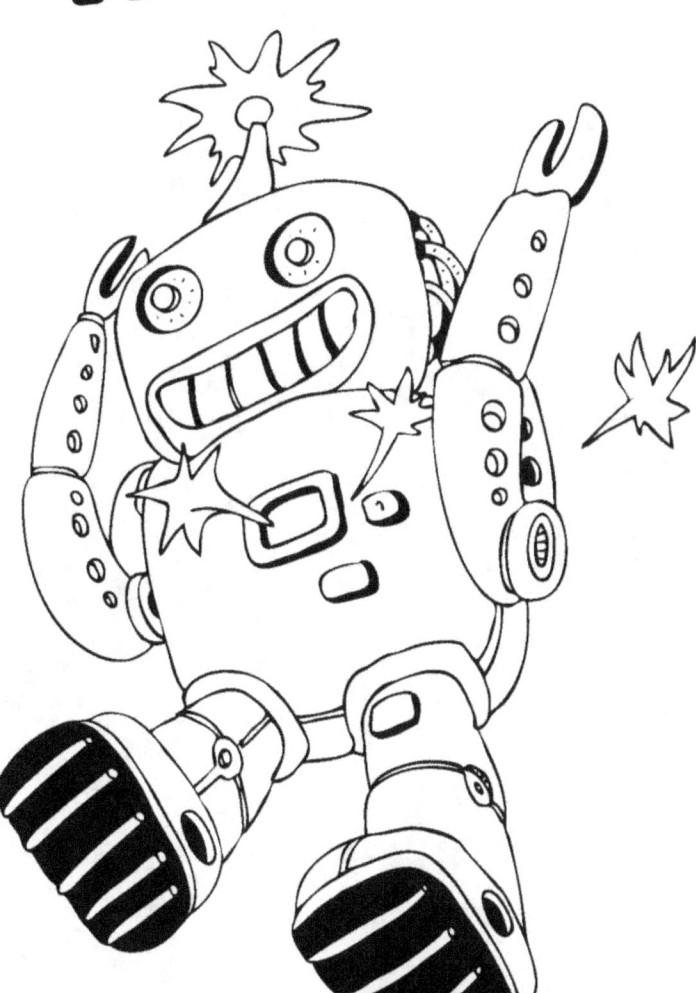

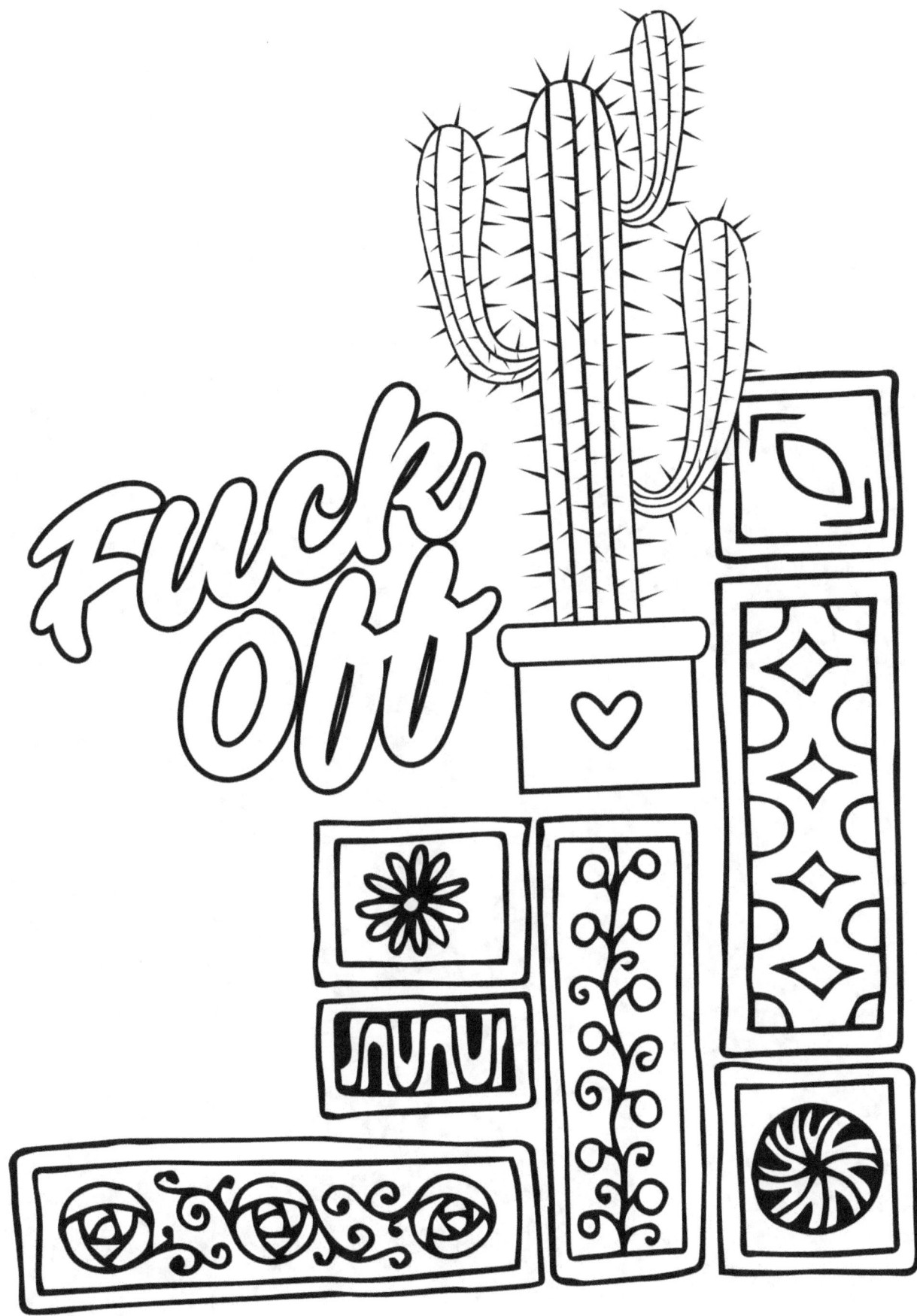

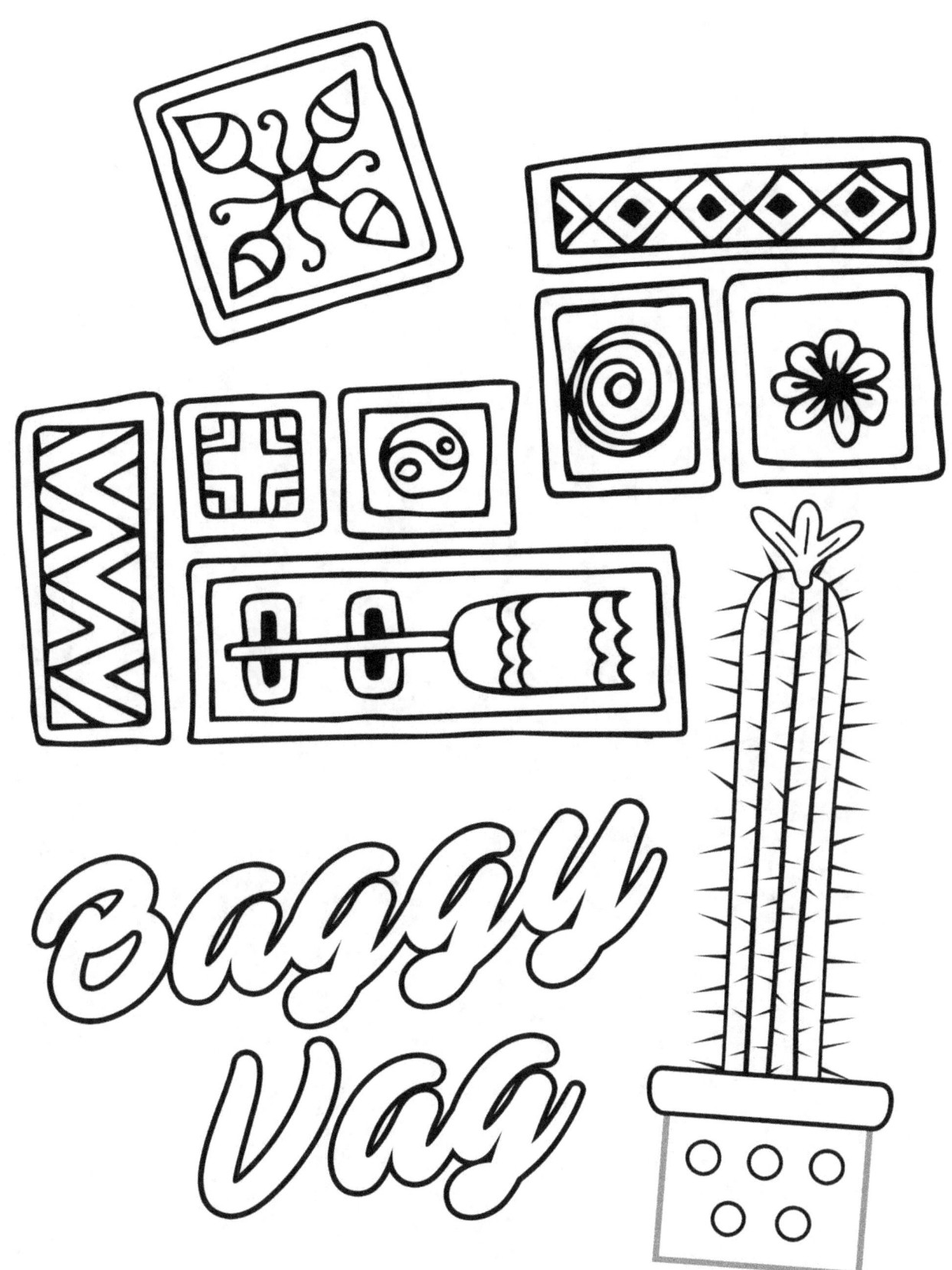

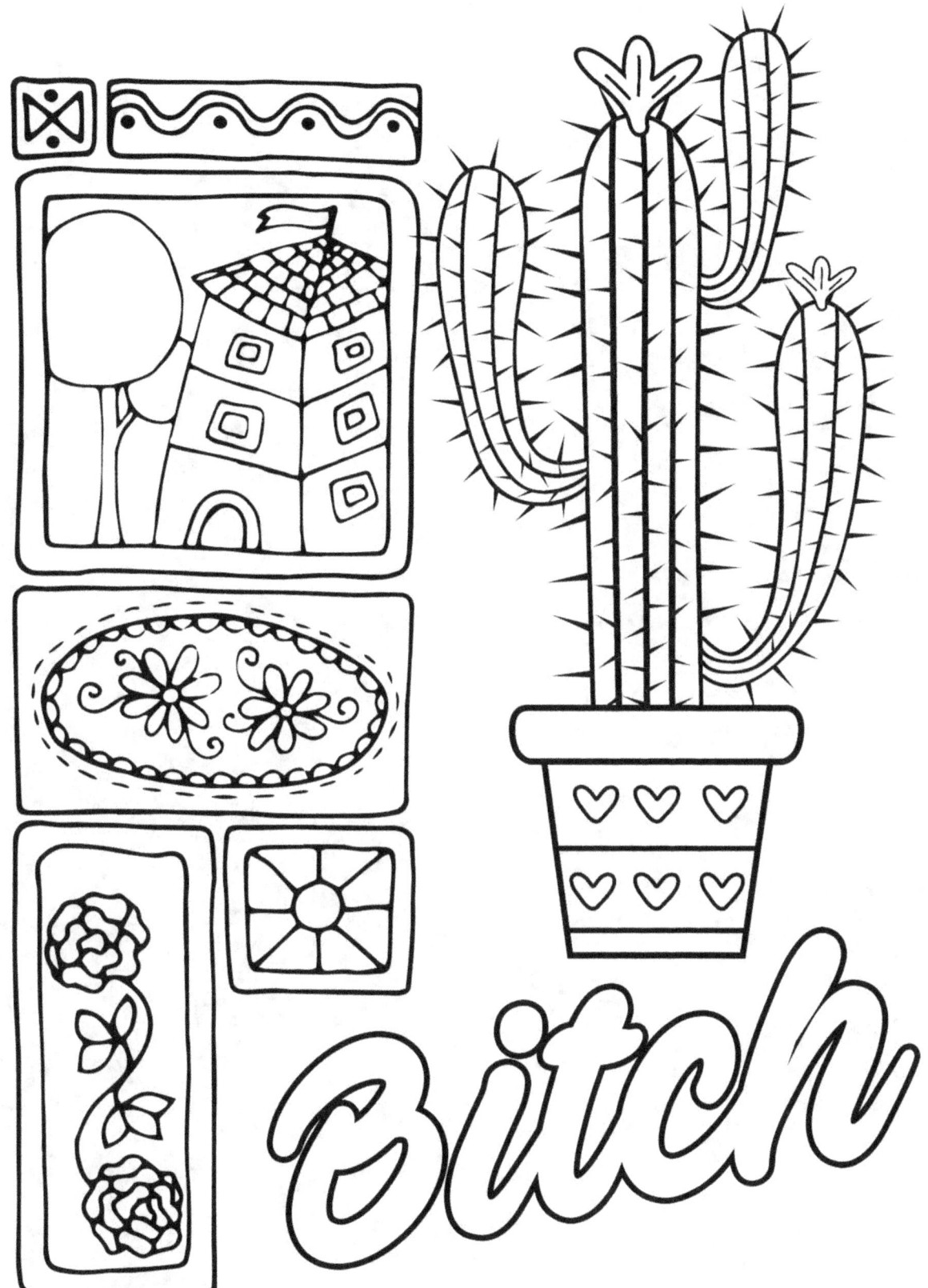

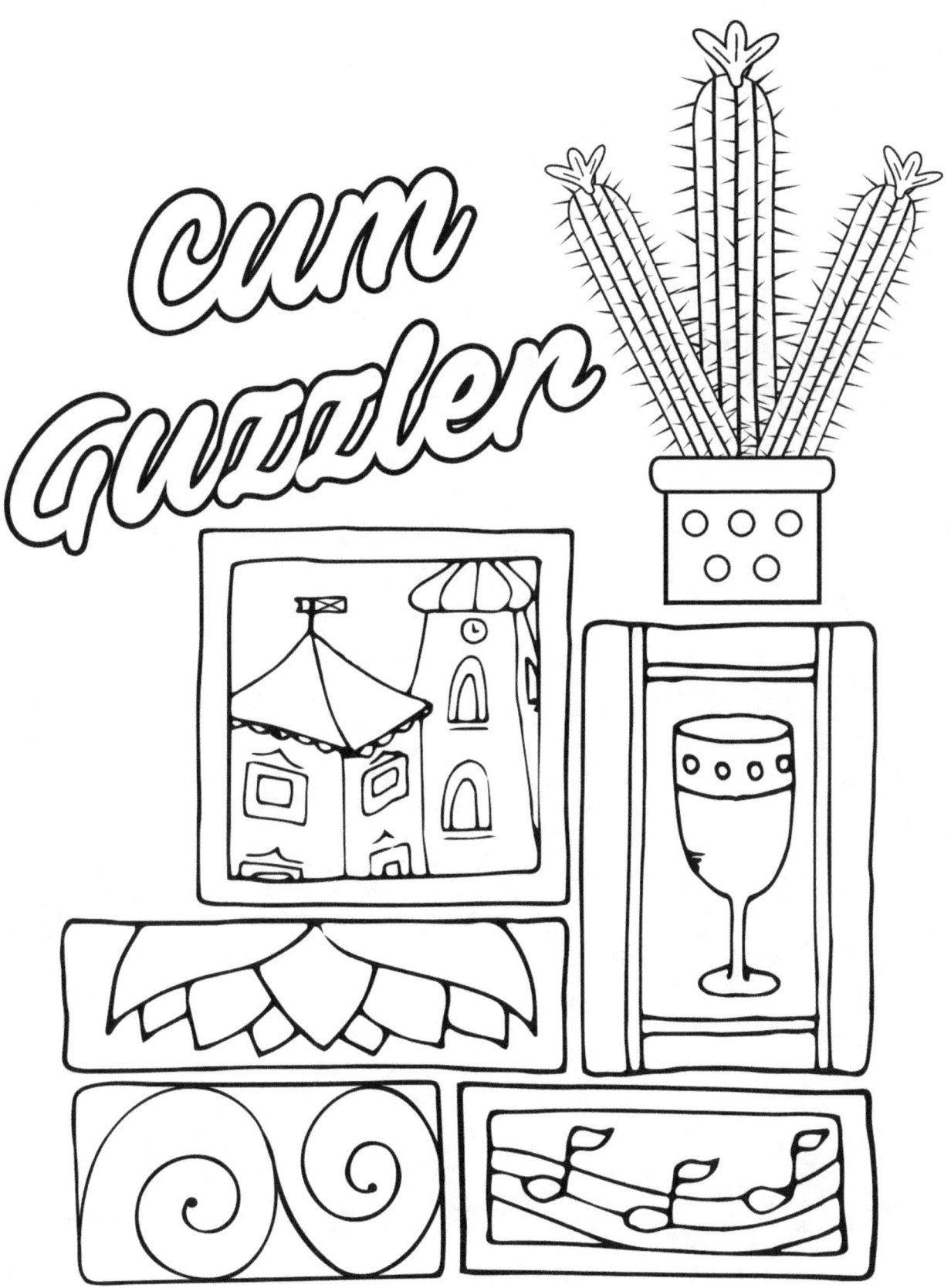

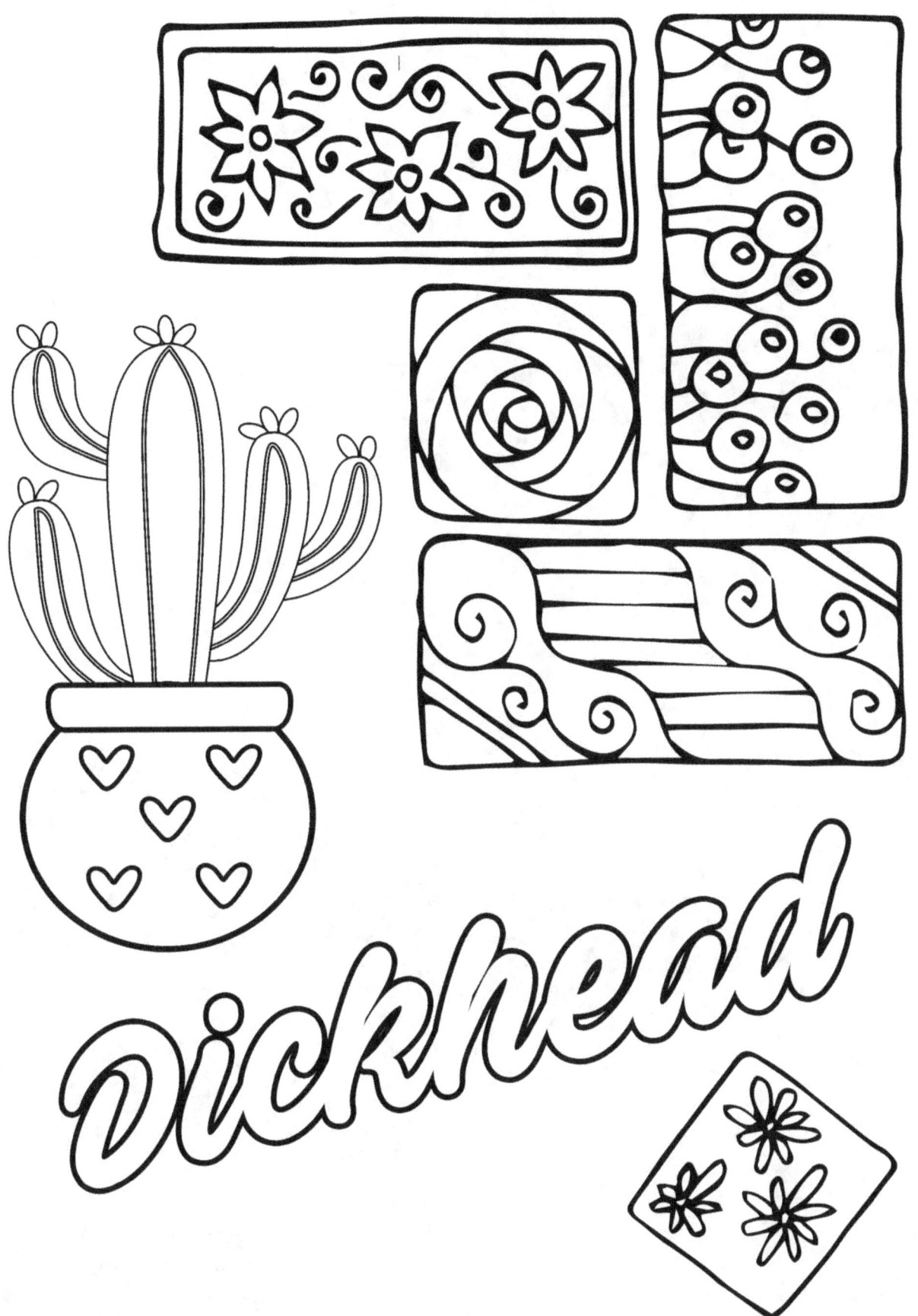

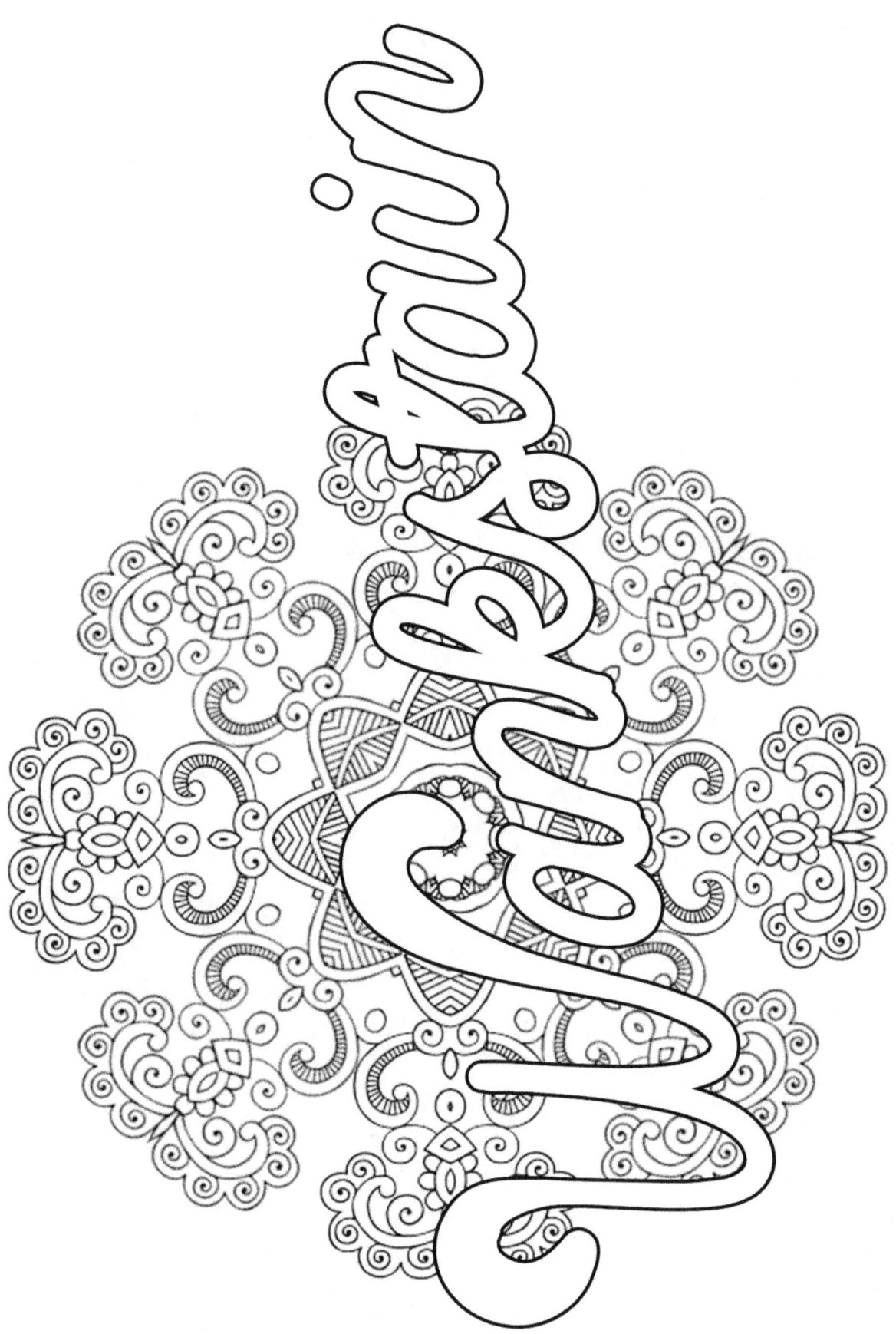

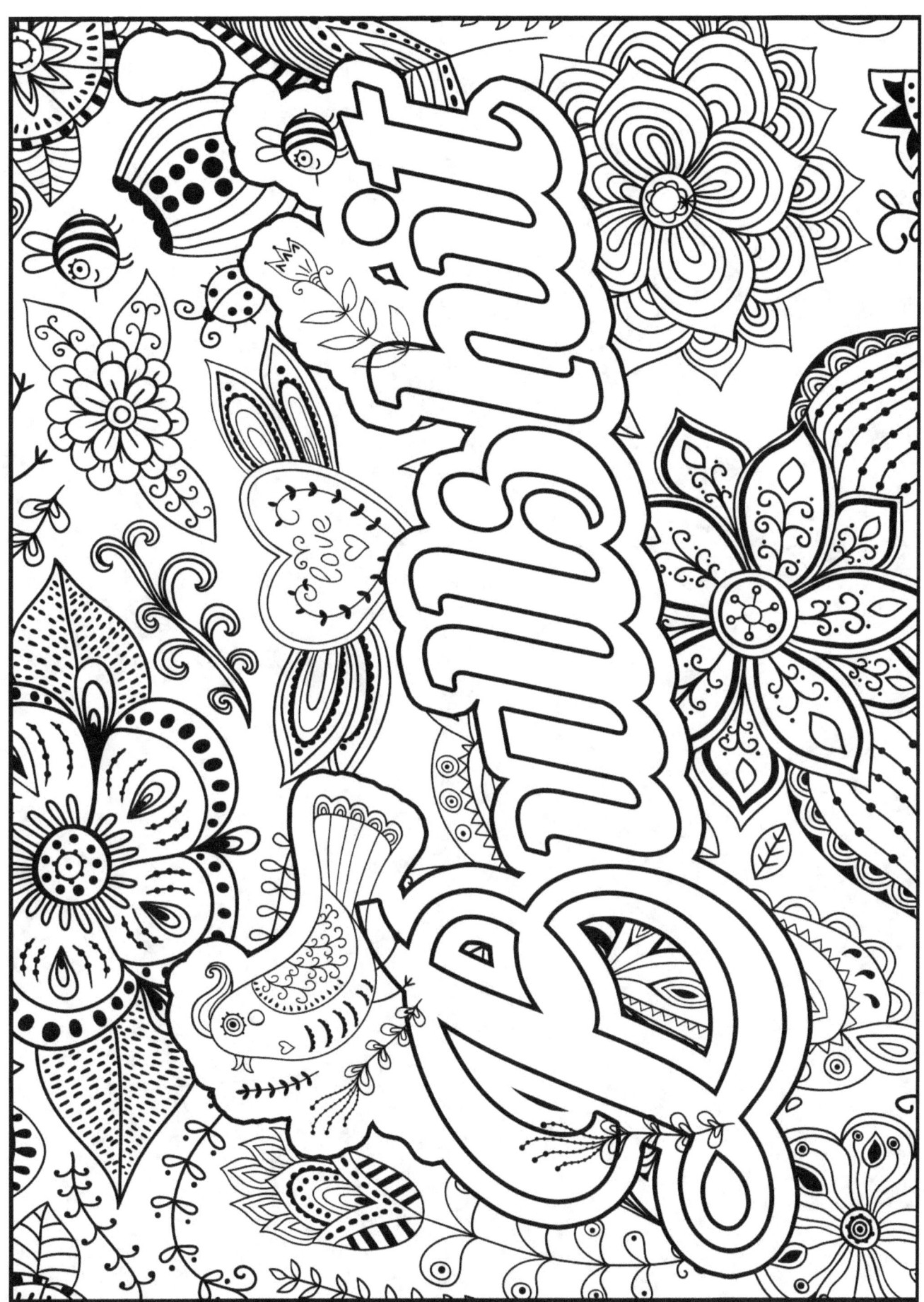

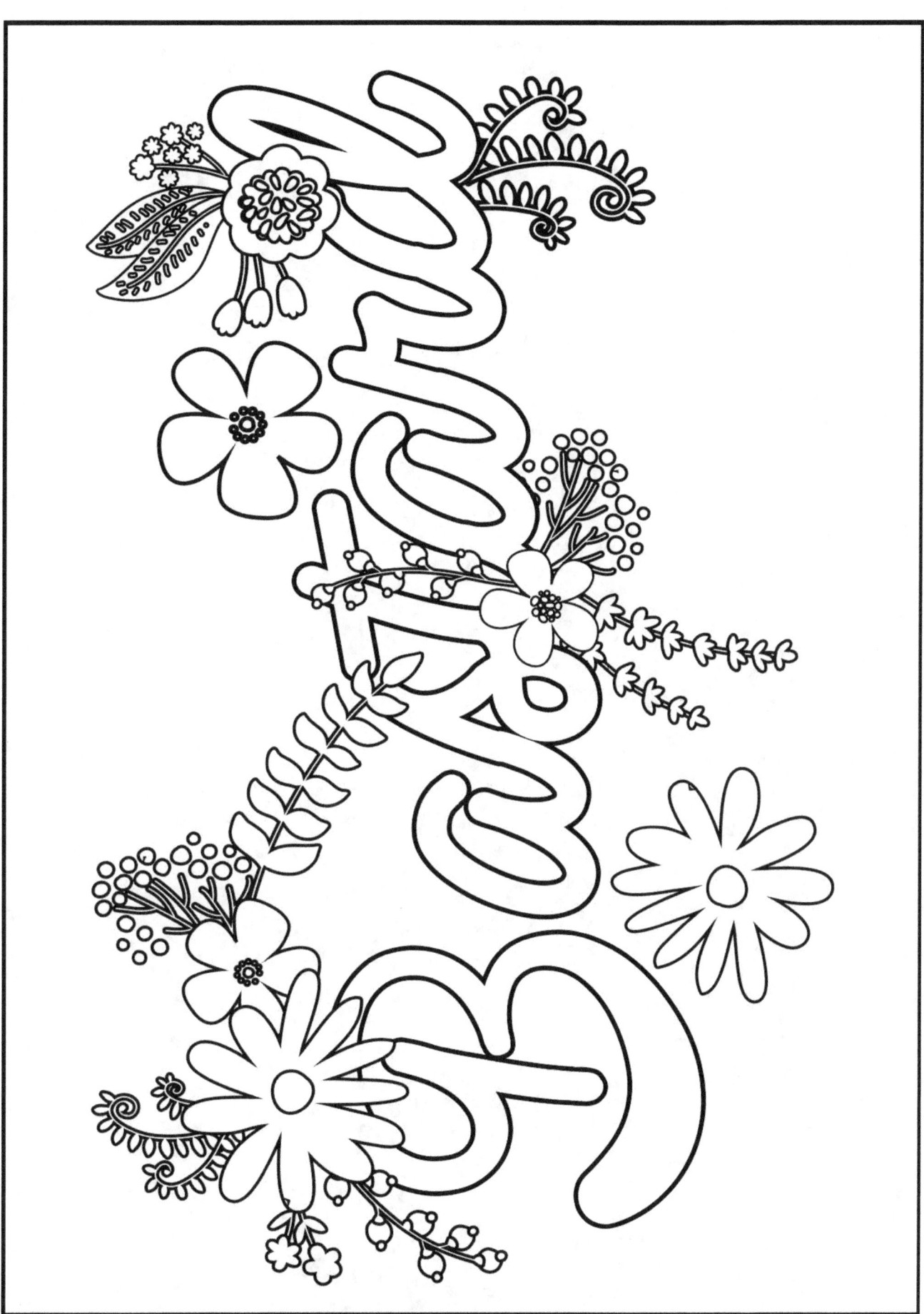